Coloring Geometric Images

Deltaspektri

Coloring Geometric Images
Sympsionics Design
Copyright © 2014 Päivi Halmekoski

ISBN 978-952-68217-0-2

Published by
Deltaspektri
Espoo, Finland

Contents

Coloring Techniques

Colored pencils are excellent for coloring geometric images and can be used in many ways to create different textures.

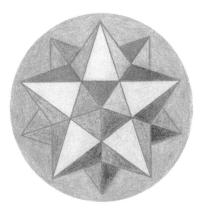

One way of using a colored pencil is to hold it in the regular way, like a normal pencil. The coloring movement can be either back-and-forth or somewhat circular. An image created using this technique can be seen on the top right-hand side of this page.

You can also hold the colored pencil at an angle and use the side of the tip for coloring. This technique is illustrated in the image on the left. On the right is an example of coloring performed in this way.

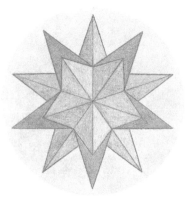

You can sharpen a colored pencil to add shavings on top of the picture. To add further color, simply press down on the shavings and move your finger around. An example of the results of this technique can be seen in the bottom right-hand image.

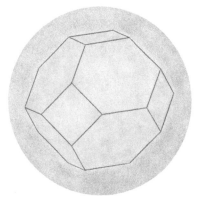

Using the Pencil at an Angle

When you hold a colored pencil almost horizontally at an angle, the intensity of the color depends on how close your grip is to the tip of the pencil. The simplest way to achieve intense coloring is to hold the pencil near the tip. Gripping the pencil in this way will give you lots of control over the tip's movement, helping you to achieve a circular coloring motion. Conversely, by gripping the pencil further away from the tip and using a back-and-forth motion, you can produce a color of lighter intensity, enabling you to color large areas quickly.

Using Shavings from a Pencil Sharpener

If you are planning to use pencil sharpener shavings, it is advisable to start with a test coloring on a different piece of paper. Depending on the pencil and its color, using shavings may result in a slightly smudgy image. Darker colors are especially risky in this regard. If the surface of the pencil is colored, it is best to remove the wooden flakes from the paper before rubbing because they may produce dark lines. The quality of the pencil will have a major effect on the results.

Shavings are useful for coloring large areas such as the background of an image. They can also be used to soften the tone of an area that has already been colored.

Different Kinds of Coloring Styles

Below are some images that illustrate the different results you can obtain, depending on whether you hold the colored pencil at an angle or with a regular grip. Different colors and brands of pencils produce somewhat different outcomes. You can increase the smoothness and glow of coloring by adding a layer of very light color such as white, cream, yellow or light blue. Cream and yellow should be avoided on blue because they add a greenish tint.

with a regular grip on the pencil, back-and-forth

with a regular grip on the pencil, circular

hold the pencil at an angle, back-and-forth

hold the pencil at an angle, circular

hold the pencil at an angle, circular + white

hold the pencil at an angle, circular + cream (avoid on blue)

In the images below, all of the color textures have been created by holding a colored pencil at an angle and using a circular movement. The base color in each image is the same shade of green, to which different colors have been added. In the middle image on the bottom row, a new layer of green has been added on top of a lighter colored layer. This creates a deeper and smoother shade of green.

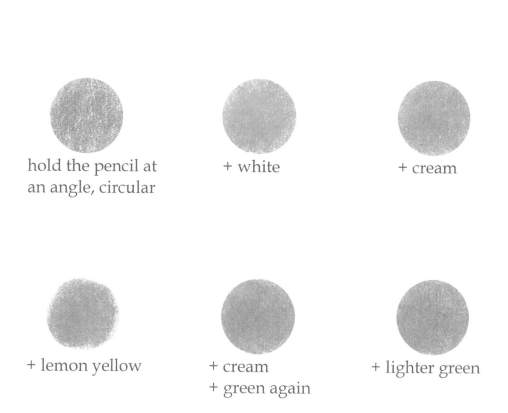

hold the pencil at
an angle, circular

+ white

+ cream

+ lemon yellow

+ cream
+ green again

+ lighter green

In the examples shown on the next page, different colors have been applied on a blue base. Where only the color is mentioned below an image, the color was produced by holding the pencil at an angle and using a circular motion. When you use the same color to make another layer, you can create a deeper shade by first rubbing the color with your finger. You can also use pencil sharpener shavings when rubbing. In these images, the shavings have been created by sharpening a pencil of the same blue color. The shavings can be used to produce a smoother shade, on top of which you can add a new layer of color. White layers can be created using shavings produced by sharpening a white pencil.

with a regular
grip on the pencil,
circular

hold the pencil at
an angle, circular

hold the pencil at
an angle, circular
+ white

blue
+ white
+ blue

blue + rubbed
with a finger
+ blue

blue
+ blue shavings

hold the pencil at
an angle, circular
+ blue shavings
+ blue

blue shavings

blue shavings
+ blue

On the next page, various textures have been created in green. The pencils have been held at an angle and a circular coloring motion has been used. Very deep shades of green can be produced by creating a cream colored layer, or by using green sharpener shavings to add a layer between two layers of green. The surface underneath the paper also has an effect on the coloring results. In two of the examples, the surface was a wooden table whose surface texture shows through in the coloring. Due to their smooth covers, some books make excellent coloring surfaces.

green
+ cream
+ green

green
+ rubbed with a
finger
+ green

green
+ green shavings

green
+ green shavings
+ green

green on a
wooden table

green on a
wooden table and
heavy paper

green shavings

green shavings
+ green

only green

A ruler can be useful when coloring geometric images and can be used to create an even boundary in a colored area. The picture below shows two colored areas that partly overlap. The coloring was performed by holding the pencil at an angle and applying light pressure in a back-and-forth motion.

The triangle below has been drawn using a colored pencil and ruler. If you are using a dark color, you can initially leave some lighter areas in the picture. You can then create bright, radiant areas by applying a light color, such as white, cream or yellow. In this example, a layer of cadmium yellow has been used on red.

Drawing a Flower Shape

1. Use a ruler to draw a square and mark its center. You can find the center by placing the ruler on the square in such a way that it connects opposing corners, thus bisecting the square. Use a regular pencil to draw a diagonal between the corners. Apply light pressure so that you can erase the diagonal later. Next, move the ruler so that it connects the two remaining corners and draw another diagonal. The center of the square is the point at which the diagonals intersect.

Place the needle of a compass at the center of the square and choose a radius that is half the length of one side of the square. In this way, you can draw a circle that fits perfectly inside the square.*

2. Use the ruler to find and mark the midpoint of each side of the square. Place the needle of the compass on one of the midpoints and set the compass to the same radius that you used in the last step. Then draw a semicircle inside the square and repeat this for every midpoint you marked. You have now created four semicircles that pass through the center of the square.

* Alternatively, you can begin by drawing a circle and then using a ruler to draw a square around it, so that the sides of the square touch the outline of the circle. To do this precisely with a ruler and compass, see page 42.

3. Place the needle of the compass at a point where the original circle intersects one of the square's diagonals. There are four such points and you can start with any one of them. Using the same radius as before, draw a semicircle that passes through the center of the square. Repeat the process for the three remaining points. You have now created four new semicircles. Erase the lines that are no longer needed and color the image.

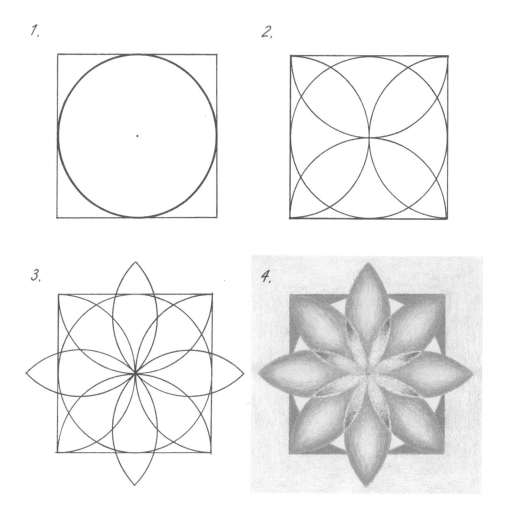

1.

2.

3.

4.

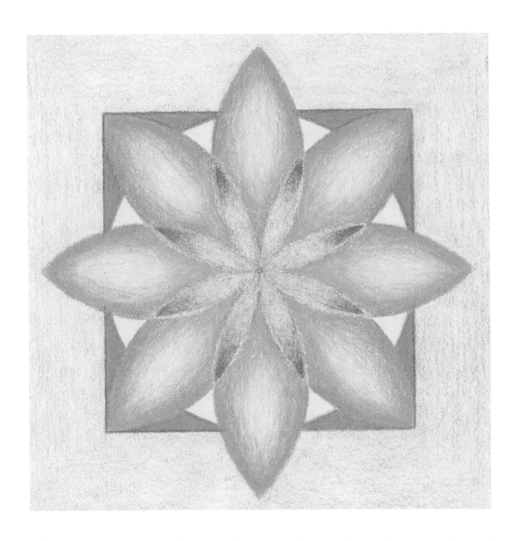

The petals in the flower image above have been colored orange, using darker shades on the edges and lighter in the middle. A layer of yellow was then applied on top of the orange. The light brown background color was created with a brown pencil at an angle, using a back-and-forth movement and applying light pressure. Using pencil sharpener shavings, a cream colored layer was applied on top of the background color. You can also create this layer using a cream colored pencil at an angle.

Drawing a Wall Shape

Use a ruler to draw a horizontal line with a length of 5.6 inches (14 cm). Add small marks along the line at 0.4 inches (1 cm) intervals. Next, draw a vertical line of the same length at the left end of the horizontal line, so that the two lines form a 90 degree angle. Add similar marks to the vertical line at 0.4 inches (1 cm) intervals.

Draw a straight line from the lowest mark on the vertical line to the right end of the horizontal line, as illustrated in the picture below. Next, connect the second lowest mark on the vertical line to the second last mark on the horizontal line. Continue connecting the marks in this way, moving one step at a time upwards on the vertical line and leftwards along the horizontal line.

In this image, the wall shape has been colored by first coloring the horizontal strips yellow and blue. A light layer of green or red was then added to some of the vertical strips so that the bottom color shows through. In some of the images in this book, sticky or post-it notes have been used to create highly precise borders between the colors. In this image, sticky notes have been used to add coloring, based on sharpener shavings, to the vertical lines. The background has also been colored using sharpener shavings.

Drawing a Diamond Shape

Use a ruler to draw a horizontal line with a length of 5.6 inches (14 cm). Draw small marks on the line at 0.4 inches (1 cm) intervals. Draw a vertical line with a length of 5.6 inches (14 cm) through the center of the horizontal line, so that the two lines bisect each other and form a right angle. Finally, add small marks to the vertical line at 0.4 inches (1 cm) intervals.

The resulting cross shape has four quadrants, which you will work on separately. In the diagram below, drawing was begun in the upper right quadrant. Use a straight line to connect the lowest mark on the vertical line to the end of the horizontal line, as shown in the image below.

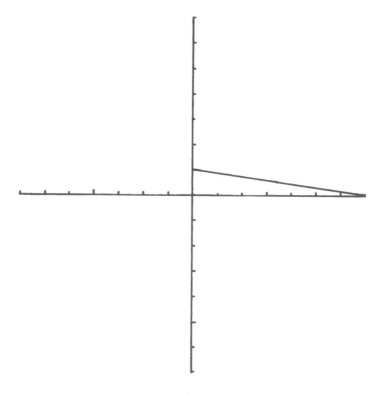

Follow this by connecting the second lowest mark on the vertical line to the second last mark on the horizontal line. Continue connecting the marks on the lines in this way, by moving one step at a time upwards on the vertical line and leftwards along the horizontal line.

Repeat this process for the remaining three quadrants. If necessary, you can rotate the paper so that the quadrant you are working on is always the top right quadrant.

The final result is shown on the next page.

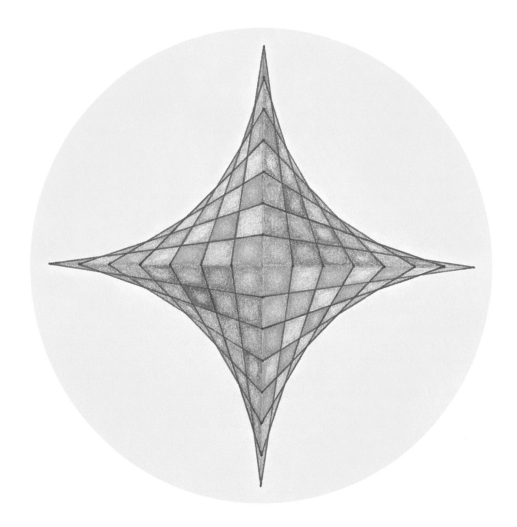

This diamond shape was colored in a checkered style alternating between blue and red, or dark blue and purple. The small quadrilaterals were colored by leaving a lighter area in the middle, to which a layer of light color was added. A layer of cream was added to the red and purple areas and a lighter shade of blue was added to the blue areas. Yellow sharpener shavings were use to create the background.

Geometric Coloring Images

In the second part of the book, you will find blue outlines forming a range of three-dimensional geometric shapes. There are two images for each shape. In each case, the first image is intended to help you to visualize the three-dimensional shape and the second is for coloring.

You can use the model image to copy the shape by hand onto paper of your own. When doing this, it may be best not to aim for absolute perfection – simply try to form the basic profile of the shape. Precise drawing instructions for a small and great stellated dodecahedron, as well as for many other three-dimensional objects, can be found in the book *Drawing Geometric Solids*.

When using a model image to draw a shape on your own paper, begin by marking the corner points. Then use a ruler to connect them. If the image has one object inside another, draw the edges of the outer object before finding the corner points of the inner one. You can also choose to draw only one of the objects. Finally, color your image.

An Octahedron Inside a Cuboctahedron

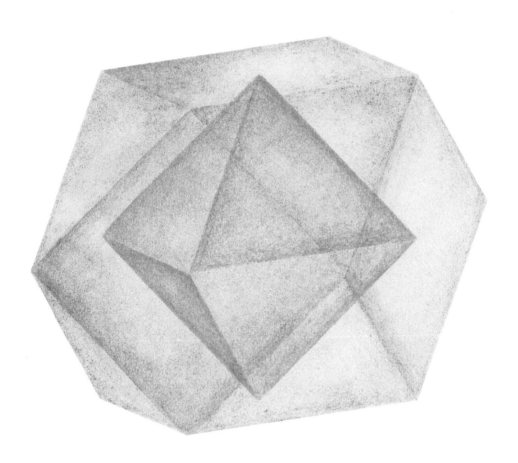

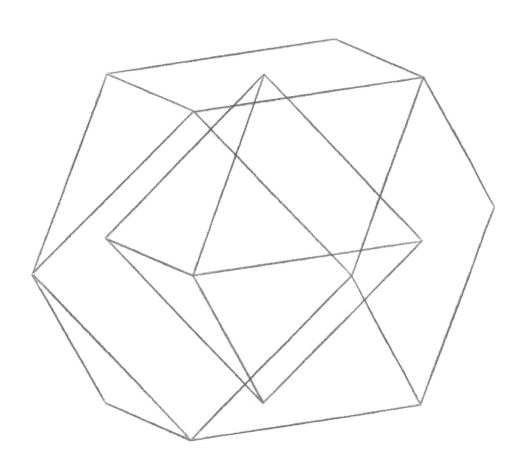

A Great Stellated Dodecahedron

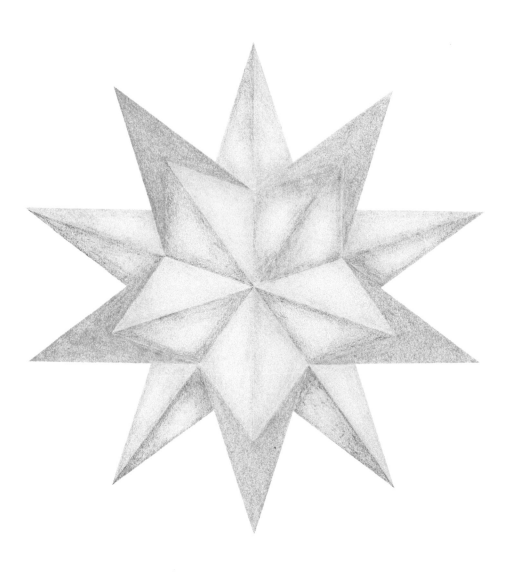

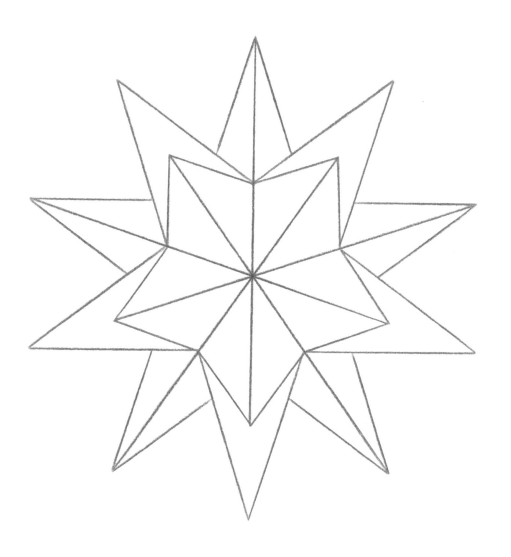

A Great Stellated Dodecahedron from a Different Angle

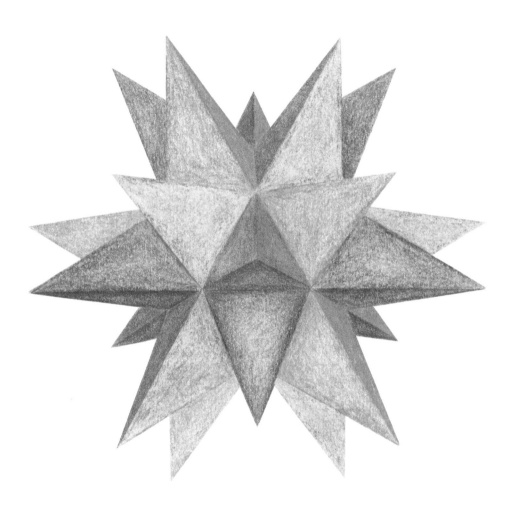

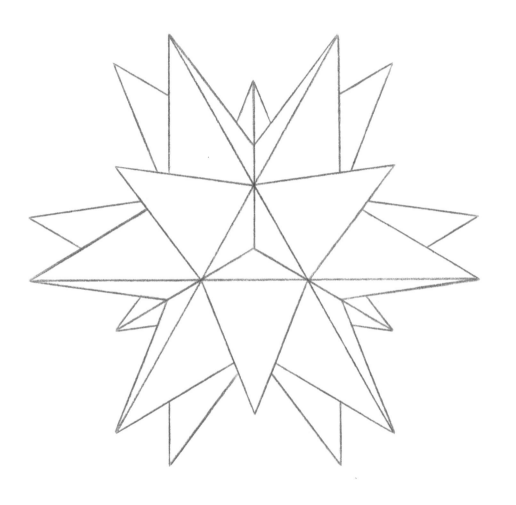

Three Intersecting Planes

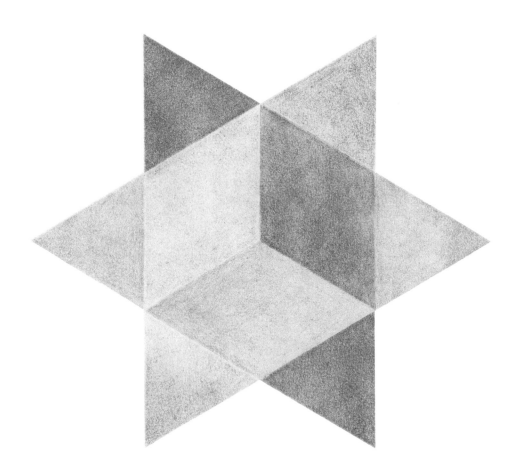

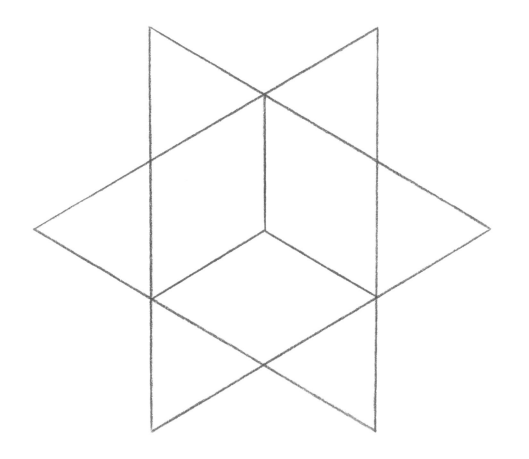

A Dodecahedron Inside an Icosahedron

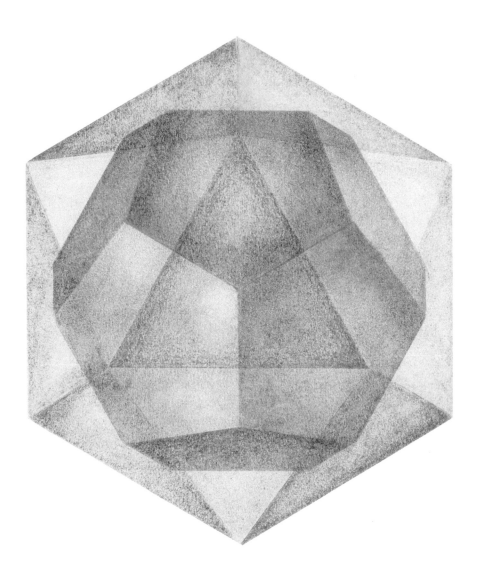

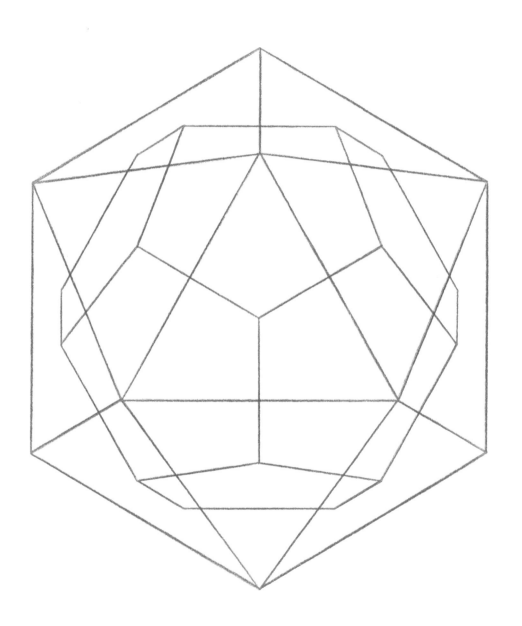

An Icosahedron Inside a Dodecahedron

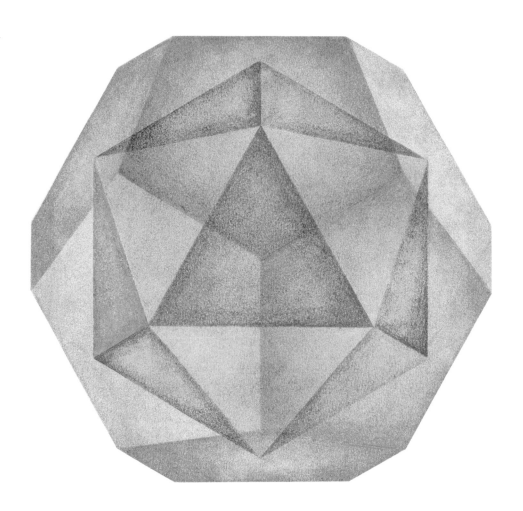

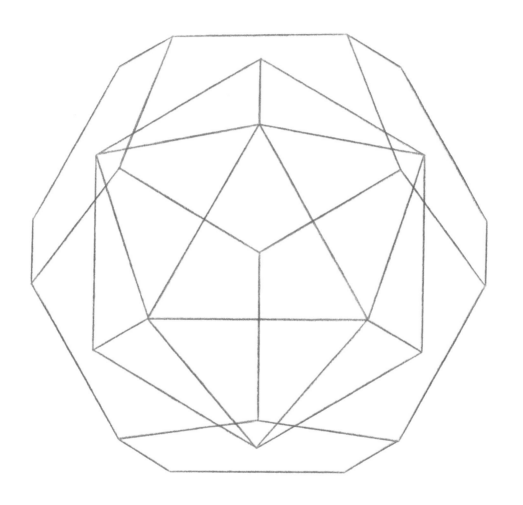

A Transparent Rhombic Dodecahedron

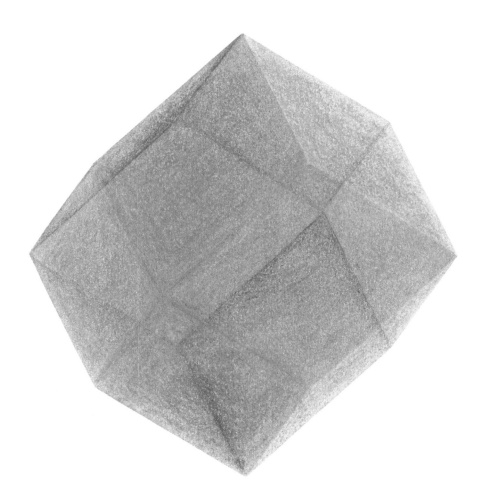

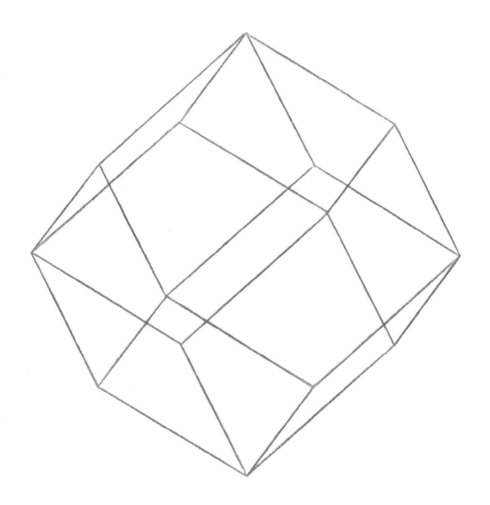

A Small Stellated Dodecahedron

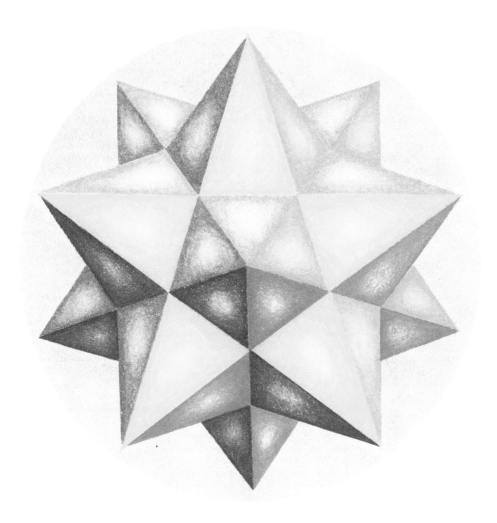

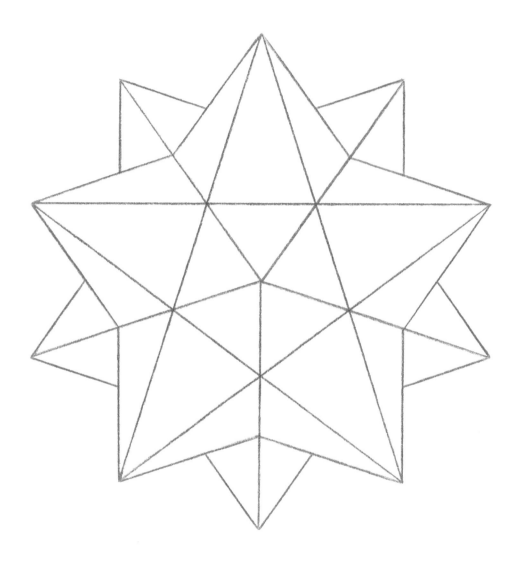

A Small Stellated Dodecahedron from a Different Angle

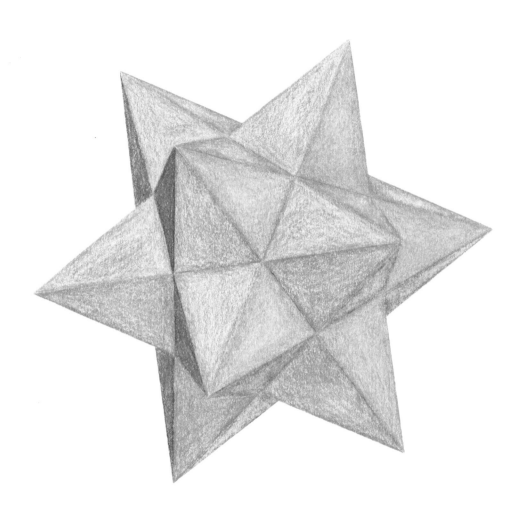

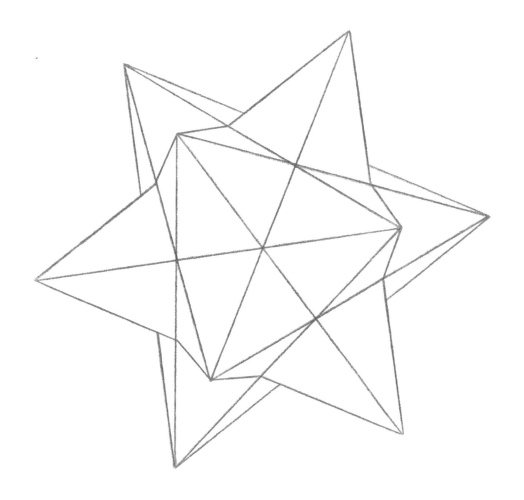

Drawing a Square around a Circle with a Ruler and Compass

1. Draw a point and use it as the origin for a circle. Draw a horizontal diameter through the origin. Place the needle-point of the compass on the leftmost point of the diameter. Increase the radius of the compass so that you can draw short arcs above and below the circle. Draw one arc above and another below the circle, as in picture 1. Keep the compass open at the same radius and move the needle-point to the rightmost point of the diameter. Draw two short arcs above and below the circle, as in picture 1. Connect the intersection points above and below the circle. You have now drawn a vertical diameter that is perpendicular to the horizontal diameter.

2. Erase the horizontal and vertical diameters. You now have four marks along the circle's circumference.

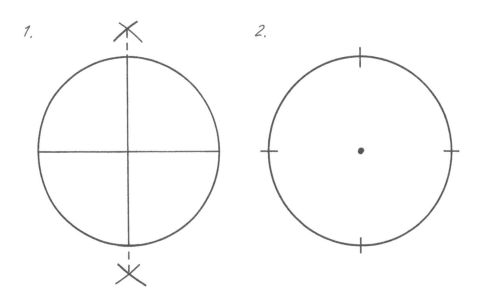

3. Set the compass to the radius of the original circle. Place the needle-point on one of the four points on the circumference. Draw two short arcs outside the circle as shown in picture 3. Repeat for all four points on the circumference and you will have four intersection points outside the circle.

4. Connect the points of intersection outside the circle to form a square.

3.

4.

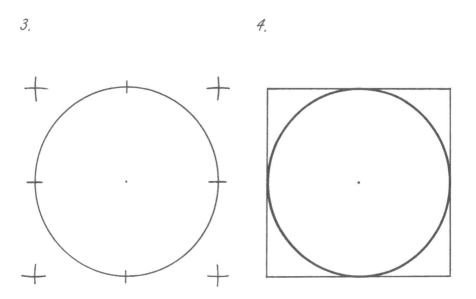

Appendix: Pictures by Kepler

Johannes Kepler (1571 – 1630), a famous German astronomer, studied the small and great stellated dodecahedrons. Below, you can see drawings by Kepler from his book *The Harmony of the World*, originally published in Latin as *Harmonices Mundi* in 1619. On the left is a small stellated dodecahedron shown from two perspectives. On the right you can see a great stellated dodecahedron, also shown from two perspectives.

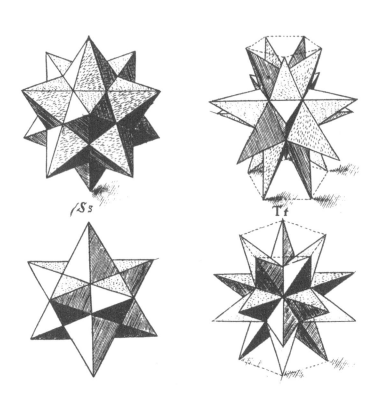

Pictured below are Kepler's illustrations of the Platonic solids. From the top left: an octahedron, a tetrahedron, a dodecahedron, a cube and an icosahedron.

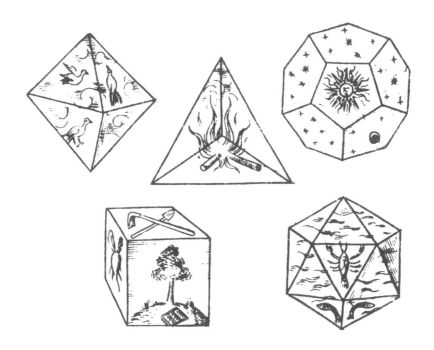

Further Reading

(in approximate order from simple to complex)

Building Platonic Solids: How to Construct Sturdy Platonic Solids from Paper or Cardboard, Sympsionics Design, Deltaspektri, 2013

Drawing Circle Images: How to Draw Artistic Symmetrical Images with a Ruler and Compass, Musigfi Studio, Deltaspektri, 2014

Drawing Geometric Solids: How to Draw Polyhedra from Platonic Solids to Star-Shaped Stellated Dodecahedrons, Sympsionics Design, Deltaspektri, 2015

Platonic and Archimedean Solids, Daud Sutton, Wooden Books, 2005

Ruler and Compass: Practical Geometric Constructions, Andrew Sutton, Wooden Books, 2009

Platonische und Archimedische Körper, ihre Sternformen und polaren Gebilde, Paul Adam & Arnold Wyss, Freies Geistesleben, 1984

Polyhedra, Peter R. Cromwell, Cambridge University Press, 1997

Other books from Deltaspektri

Drawing Circle Images

From simple to complex —
use a compass to draw
fascinating artistic images.
This book includes step-by-
step instructions for all
symmetries between
threefold and twelvefold.
Clear and precise black-
and-white illustrations will
guide you.

Building Platonic Solids

*Above: Platonic Solids built
following the instructions*

Lightning Source UK Ltd.
Milton Keynes UK
UKOW07f0648090615

253145UK00003B/8/P